# LITTLE FLAGS

## Activity Book for Littles who Favor their Right

kame bat

*To my sweet friends who continue to embrace their inner child in a way few dare and to the Caregivers who hold space so their littles can safely explore the world.*

THIS BOOK BELONGS TO

_____

Little Flags: Activity Book for Littles
Copyright © 2019 by kame bat.
All Rights Reserved.

No part of this book may be reproduced in any form
or by any electronic or mechanical means including information
storage and retrieval systems,
without permission in writing from the author.
The only exception is by a reviewer, who may quote short excerpts in a review.

Cover designed by kame bat

ALL IMAGES
found in this book are either public domain images
(as in the case of the small color flags)
or created by the author (the activity and coloring pages).

The author uses a pseudonym for reasons she need not explain.
Her resemblance to an actual person, living or dead, is NOT coincidental.
She is – after all – a real girl.

Printed in the United States of America
First Printing: April 2019
ISBN: 9781094616827

# A MESSAGE FROM THE AUTHOR

The first edition of this coloring book featured most activities and coloring pages on the left-hand side. This version is for those who prefer to color on the right side of the spread. You'll find all the major images and activities on the right side of the fold.

I hope that I have not offended anyone with my inclusion – or exclusion – of any information, terminology, or imagery in this book. There are many more pride flags and groups to represent but that will need to wait for the next book.

◆ ◆ ◆

In the coloring and activity pages, every other page is mostly blank. This was intentional to allow for coloring without bleeding through the page, doodling, and/or removal of a page if you wish to hang up your creation.

Naughty Lists: Keep track of your naughtiness (89-95)

Solutions to all activities are the end of your book (96-98).

Key to Pride Flags. The Full-Color Versions of these flags are on the back cover of your book if you want to color them realistically. You will find the flags throughout this book.

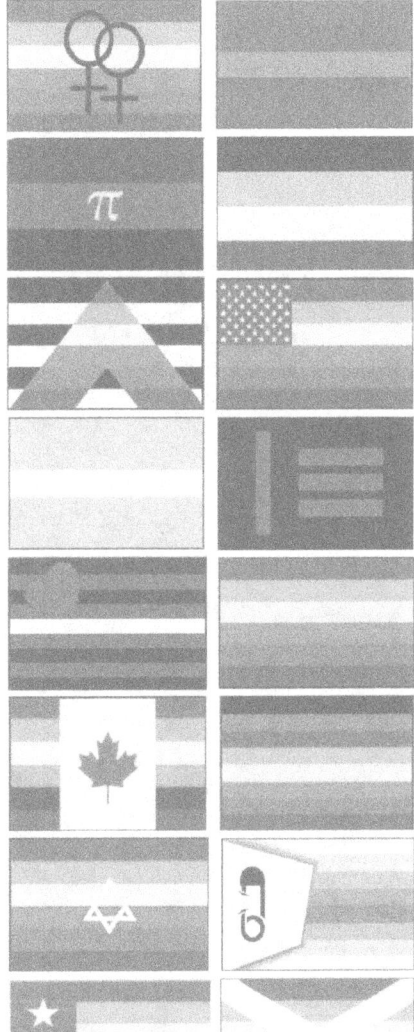

LESBIAN PRIDE
Page 43

BISEXUAL PRIDE
Page 23

POLYAMORY PRIDE
Page 49

ASEXUAL PRIDE
Page 33

ALLY PRIDE
Page 21

AMERICAN PRIDE
Page 63

TRANSGENDER PRIDE
Page 31

MASTER/slave PRIDE
Page 37

LEATHER PRIDE
Page 27

GAY PRIDE
Page 13

CANADA PRIDE
Page 67

QPOC PRIDE
Page 25

ISRAELI PRIDE
Page 65

AB/DL PRIDE
Page 57

CHILE PRIDE
Page 71

SCOTTISH PRIDE
Page 73

# St. Andrew's Sudoku

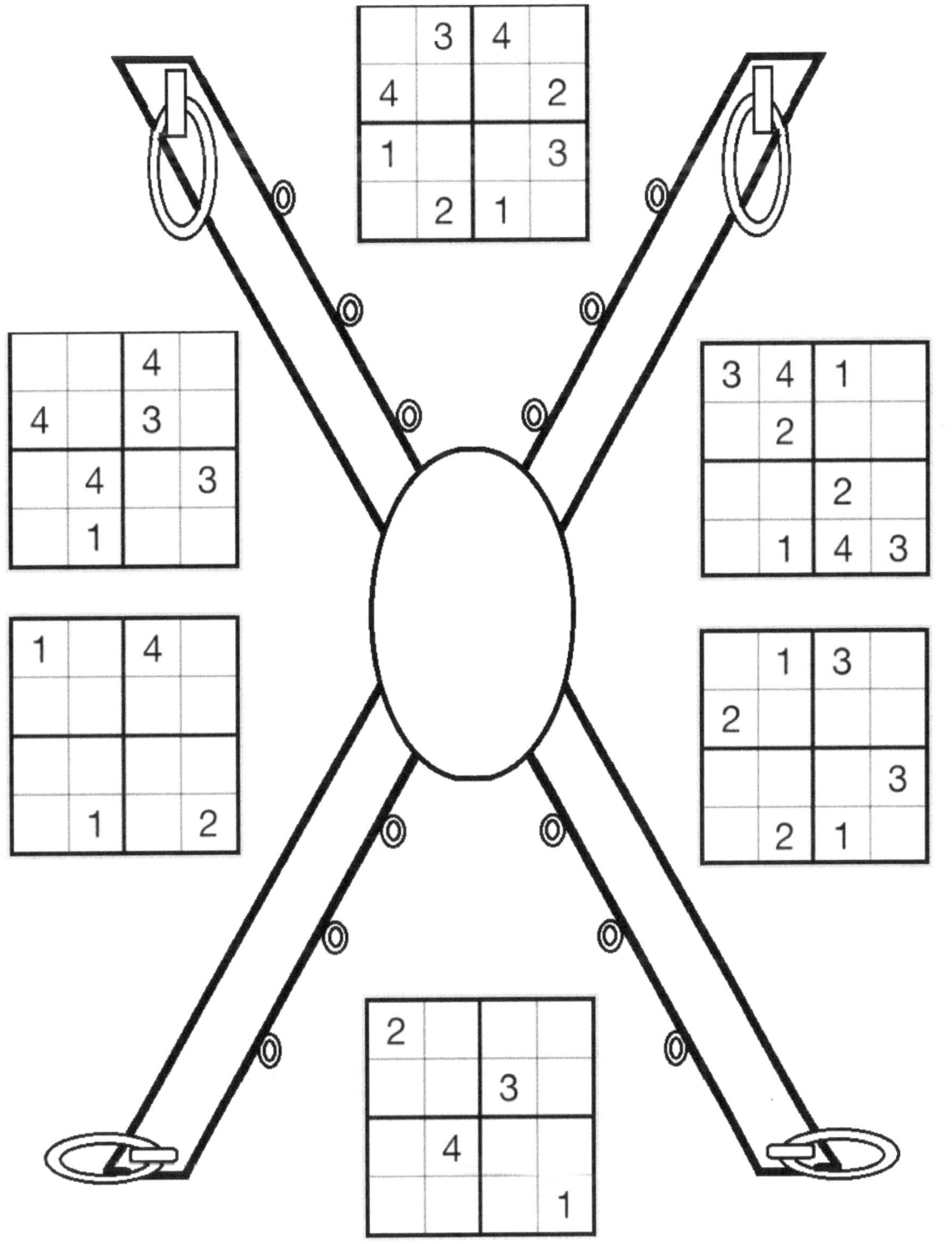

XOXOXOXO

XOXOXOXO

XOXOXOXO

XOXOXOXO

~~~PRIDE~~~

~~~PRIDE~~~

The original rainbow flag was designed by Gilbert Baker in San Francisco.

**Did You Know?**

There were seven stripes originally. Now, there are usually just six: red (on top), orange, yellow, green, blue, and violet/purple.

# GAY PRIDE

# OUT and PROUD

# OUT and PROUD

HIS & HIS

HIS & HIS

-ALLY-ALLY-ALLY-

-ALLY-ALLY-ALLY-

# STRAIGHT ALLY

A straight or heterosexual ally is a person who realizes they do not face the same obstacles that many in the LGBTQ community do every day. Instead of feeling guilty, Allies support equal rights and use their power and voice to fight homophobia, biphobia and transphobia.

Michael Page designed the Bi Pride flag in 1998 to increase visibility of bisexuals. The color pink represents attraction to the same sex only (gay and lesbian). Blue represents attraction to the opposite sex only (straight). The overlap creates purple to represent attraction to both or all.

BISEXUAL PRIDE

# QUEER PEOPLE OF COLOR

# QPOC PRIDE

The Philadelphia Pride flag or QPOC (Queer People of Color) flag was created to highlight inclusivity and was released for public use by its creator (Tierney) and the Philadelphia City Council.

*LEATHER*

*LEATHER*

The Leather Pride Flag (designed by Tony DeBlase) was embraced by the Gay Leather Community and is now associated with related groups as well. DeBlase said it is up to individuals to interpret his design, but many say the heart stands for love, the white stripes represent honesty & transparency, and the black and blue stripes mimic the two materials commonly worn and erotized in the Leather Community (leather and denim).

## LEATHER PRIDE

# HANKY CODE

Master Hank went to get condoms and got lost. Help him find his way back to Thyler

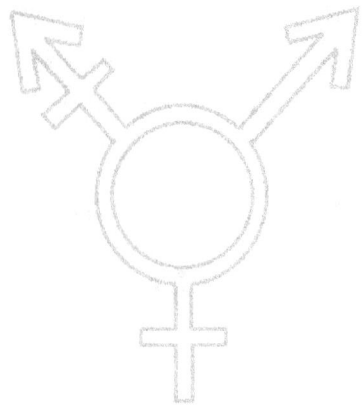
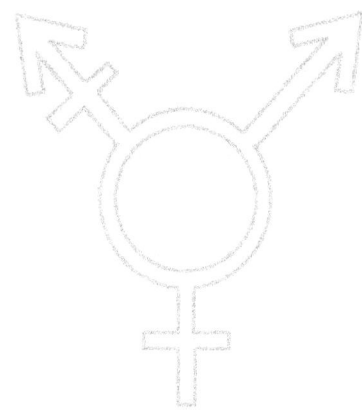

# TRANSGENDER PRIDE

The Transgender Pride Flag was designed by Monica Helms. Blue and pink stripes represent the traditional colors boys and girls and white symbolizes those in transition, those who have neutral gender and those who are intersexed.

In the Asexual Pride Flag, the colors represent asexuality (black) grey-asexuality and demisexuality (grey), non-sexual partners and allies (white) and community (purple)

## ASEXUAL PRIDE

-ace-ace-ace-ace-ace-

-ace-ace-ace-ace-ace-

# M/s FLAG

The **Master/slave Flag** was designed by Master Tallen with slave Andrew. The flag is a representation of power exchange relationships like Master/slave or Dominant/submissive. The vertical stripe stands for power or the dominant person. The three horizontal stripes represent the passive or submissive individual. Master Tallen has graciously granted permission for the reproduction and dissemination of the flag.

## UNSCRAMBLE US!

**M/s**

1. RLTAEHE
2. EATSMR
3. CLLROA
4. BLCOKOATB
5. ISR
6. LSAVE
7. NKLEE
8. STSEMIRS
9. CTATRONC
10. COOLORTP
11. CNAMOMD
12. ESY
13. TPORRYEP
14. OWNRE

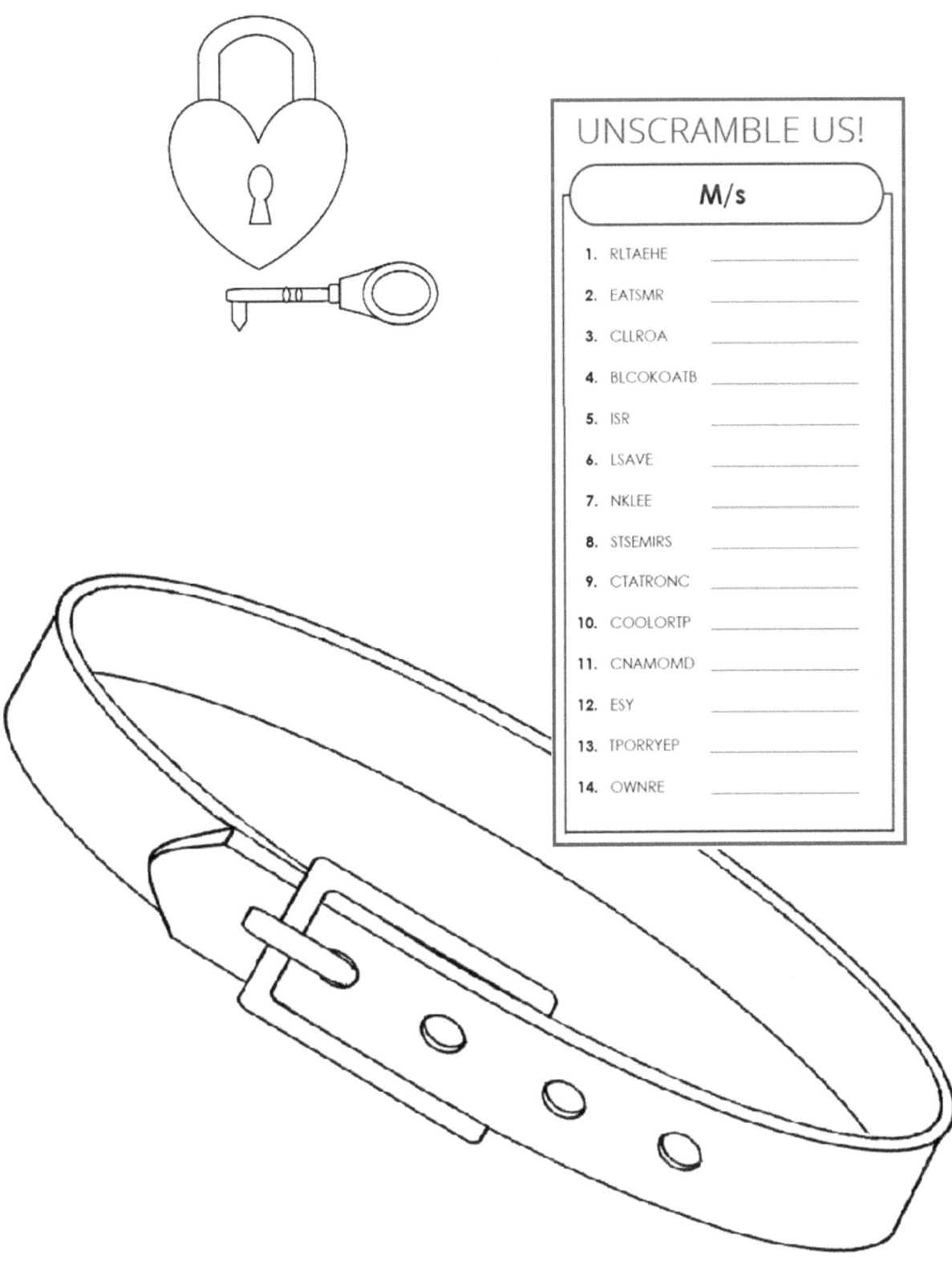

Two astronomical symbols for the planet Venus – each representing a woman – are interlocked in the Lesbian Pride Flag.

## LESBIAN PRIDE

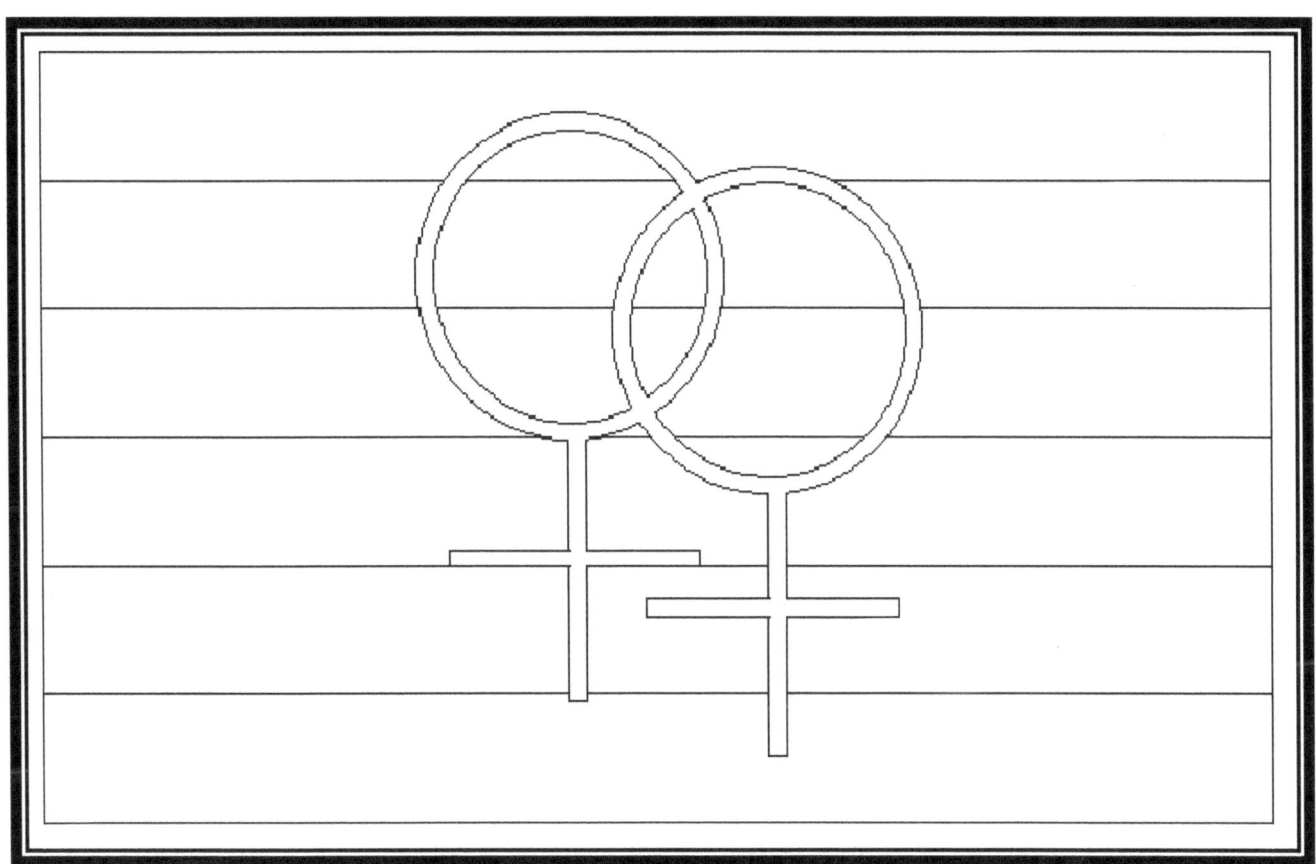

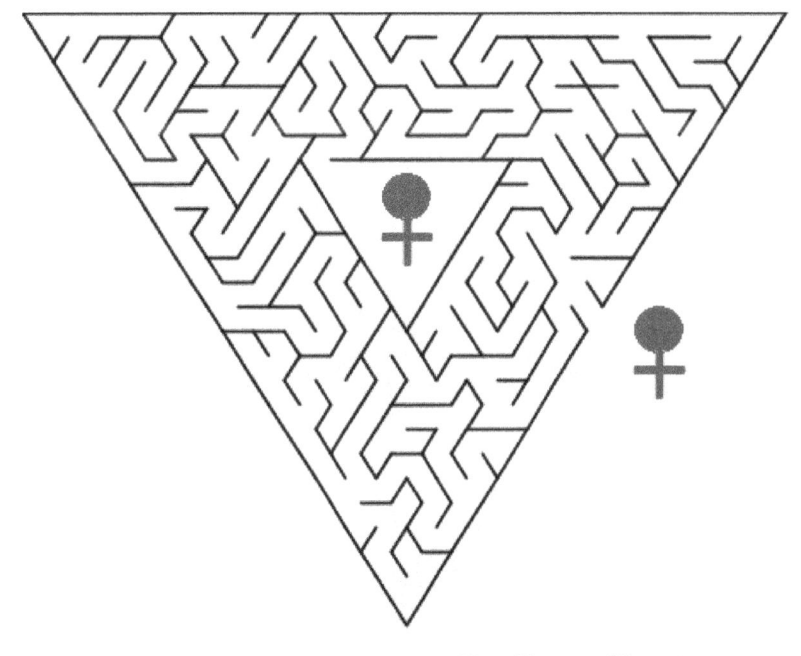

# POLY PRIDE

**Polyamory Pride Flag** consists of stripes of blue (openness & honesty), red (love & passion), and black (solidarity with those closeted due to societal pressures). The gold of the Greek letter 'pi' represents the value we place on all emotional attachment to others above and beyond the physical.

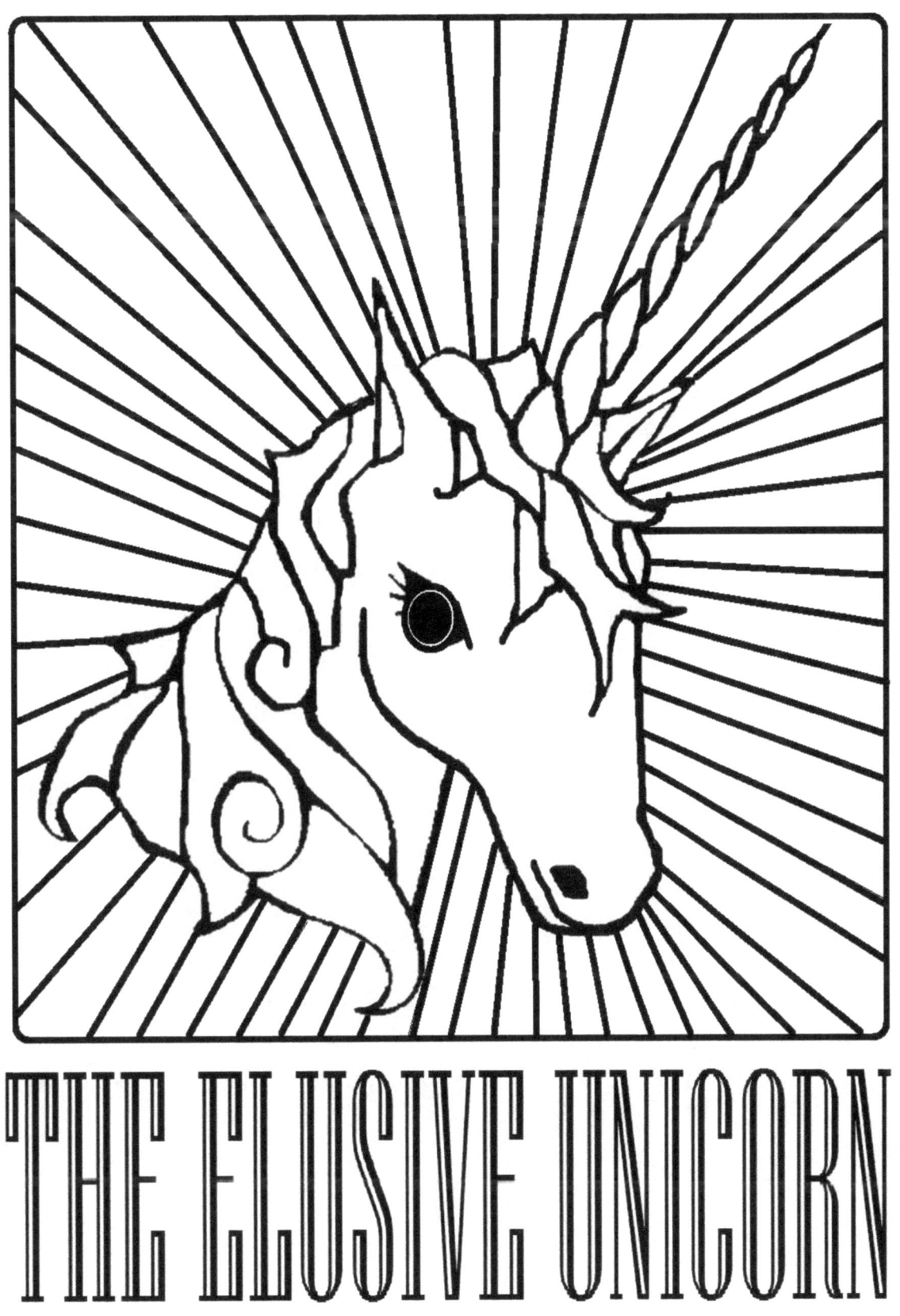

# POLYAMORY

```
Q U P P P B M M I T B D Q C I C B M
I D N I P O Y A E U R G Y T A O I Q
K M Y I V N L C N T A I T U A M Q U
S O E A C O P Y L A Y B D G P P A
O N O P D O T E F O L M P E P E O D
L O I I G S R Q H I S O O F Z R L X
O P E T E C N N F L D E V U Y S Y T
P O L Y S A T U R A T E D E R I C R
O L T M R O N H T D G W L J S O U I
L Y P A R A M O U R V A Z I K N L A
Y I F A N A R C H Y D Z N J T Y E D
P O L Y L O P E N N S P Q G V Y B E
```

Find the following words in the puzzle.
Words are hidden → ↓ and ↘ .

ANARCHY
CLOSED
COMPERSION
DYAD
MANYLOVES
METAMOUR
MONOPOLY
OPEN
PARAMOUR
PI
PIVOT
POLY
POLYCULE
POLYFIDELITY
POLYSATURATED
QUAD
SOLOPOLY
TRIAD
TRIBE
UNICORN

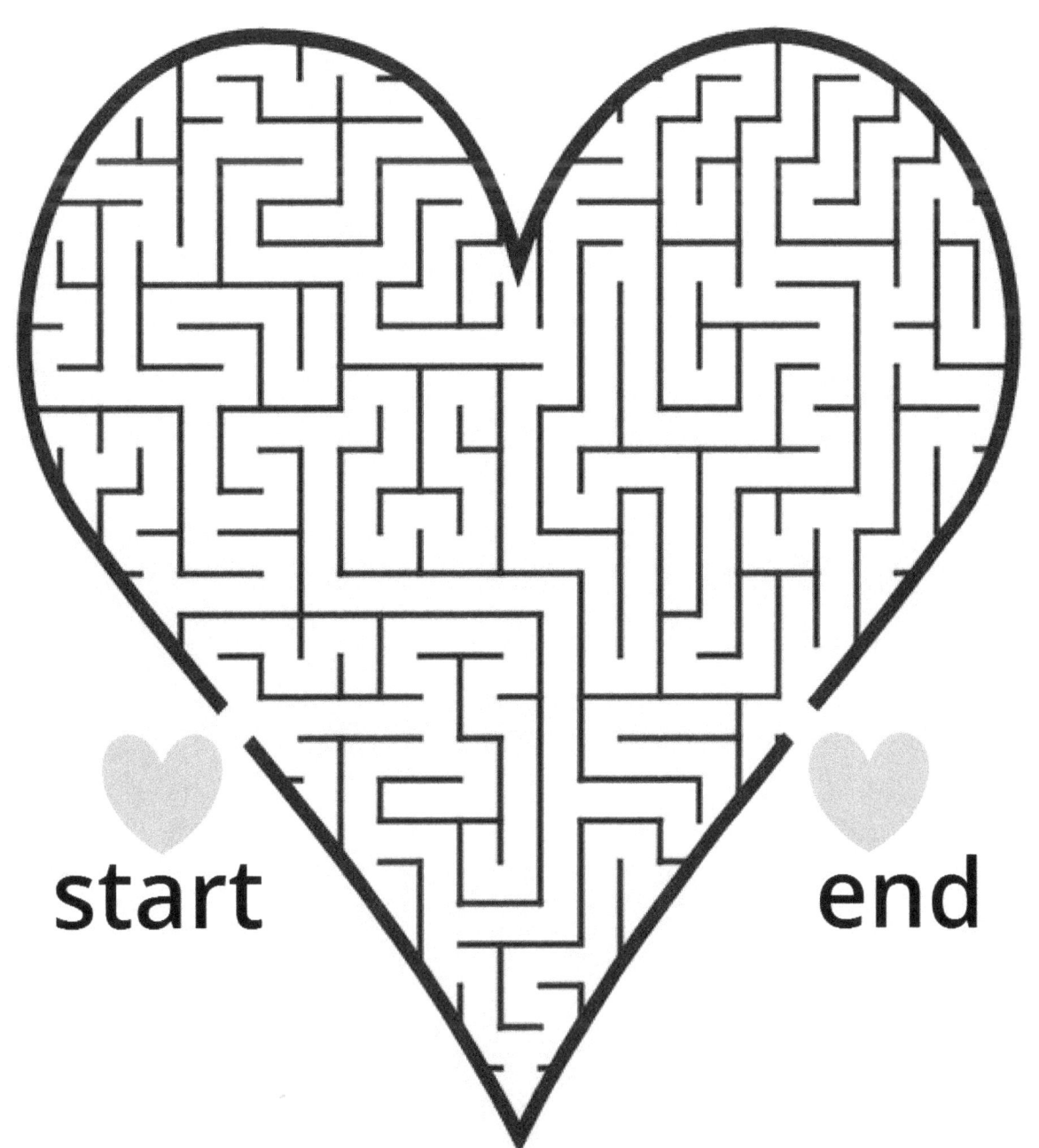

# TRAVEL THROUGH NRE

The Adult Baby/Diaper Lover (AB/DL) flag was created in 2005 by David (ABDL Scandinavia.com) for the community.

Help the Rubber Ducky find its way to the tub

# AB/DL

```
J V H T I M E O U T D I A P E R P T
I T C F A S O B F D F M O L S E N R
M H U P M N Z I O C M E K K A X Q M
G E D L I U C J N T A E I O F Z N J
I N D O L G R Q H T T R V Z E O U Y
O M L V K G I E B S M L E H X N R R
N S E I U L B H T Z S E E G P J T V
E N R N C E L C P B F B N P I X U R
S U S G J P O W D E R A I T M V R Q
I P A C I F I E R K U B R B T C E N
E S Q J Y T E D D Y L G N N T M R
P L A Y Z D M X Q R B L A N K I E I
```

Find the following words in the puzzle.
Words are hidden → ↓ and ↘ .

BABY
BIB
BLANKIE
BOTTLE
CAREGIVER
CRIB
CUDDLE

DIAPER
LOVING
MILK
NURTURE
OINTMENT
ONESIE
PACIFIER

PLAY
POWDER
SAFE
SNUGGLE
TEDDY
TIMEOUT

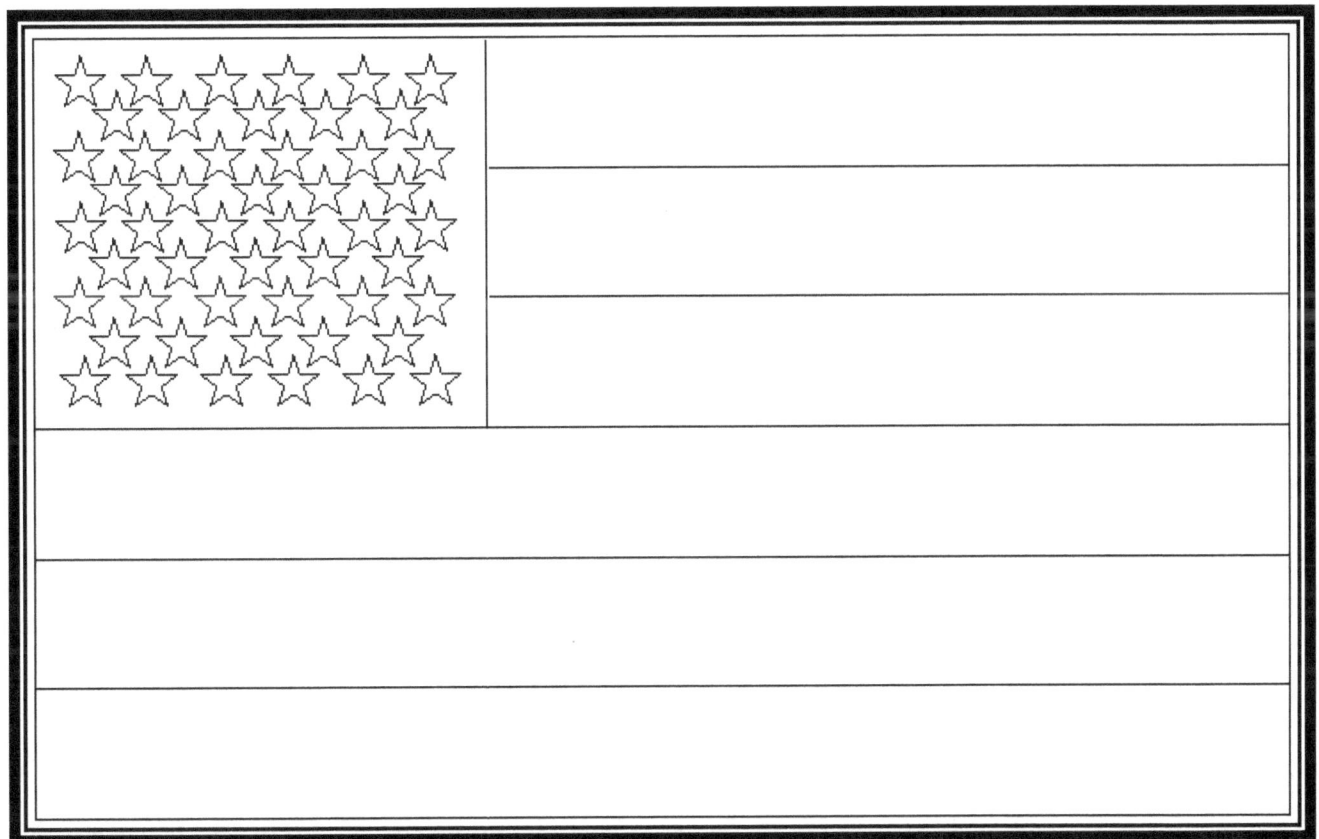

# USA PRIDE

The pride flag with stars was produced (by a company named Paramount Flags) before the rainbow flag became a gay pride symbol. The flag was popular with "rainbow children" as well.

.

## Did You Know?

Tel-Aviv has a very large pride parade! The Israeli pride flag features the Star (or Shield) of David in the center of a classic pride field of rainbow colors.

## ISRAELI PRIDE

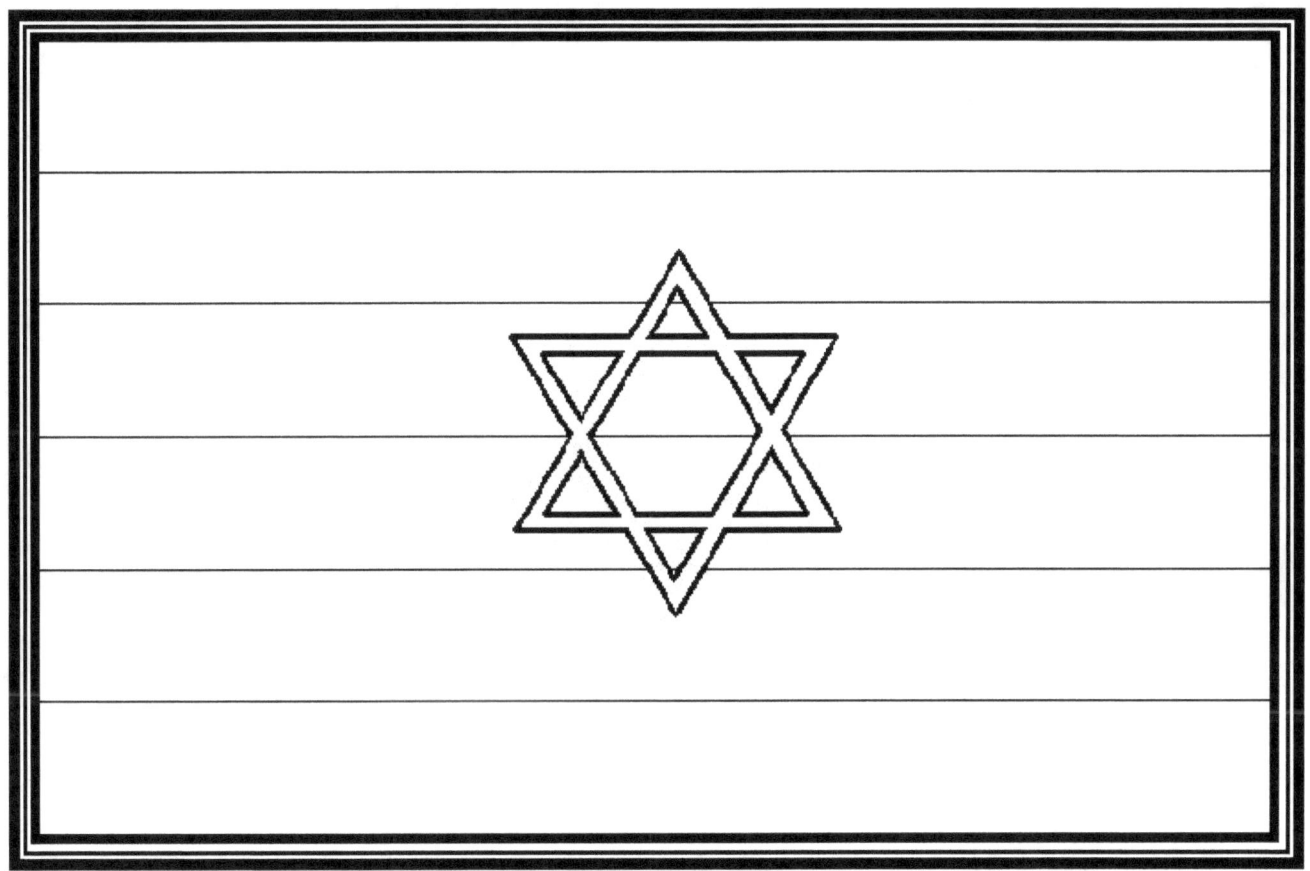

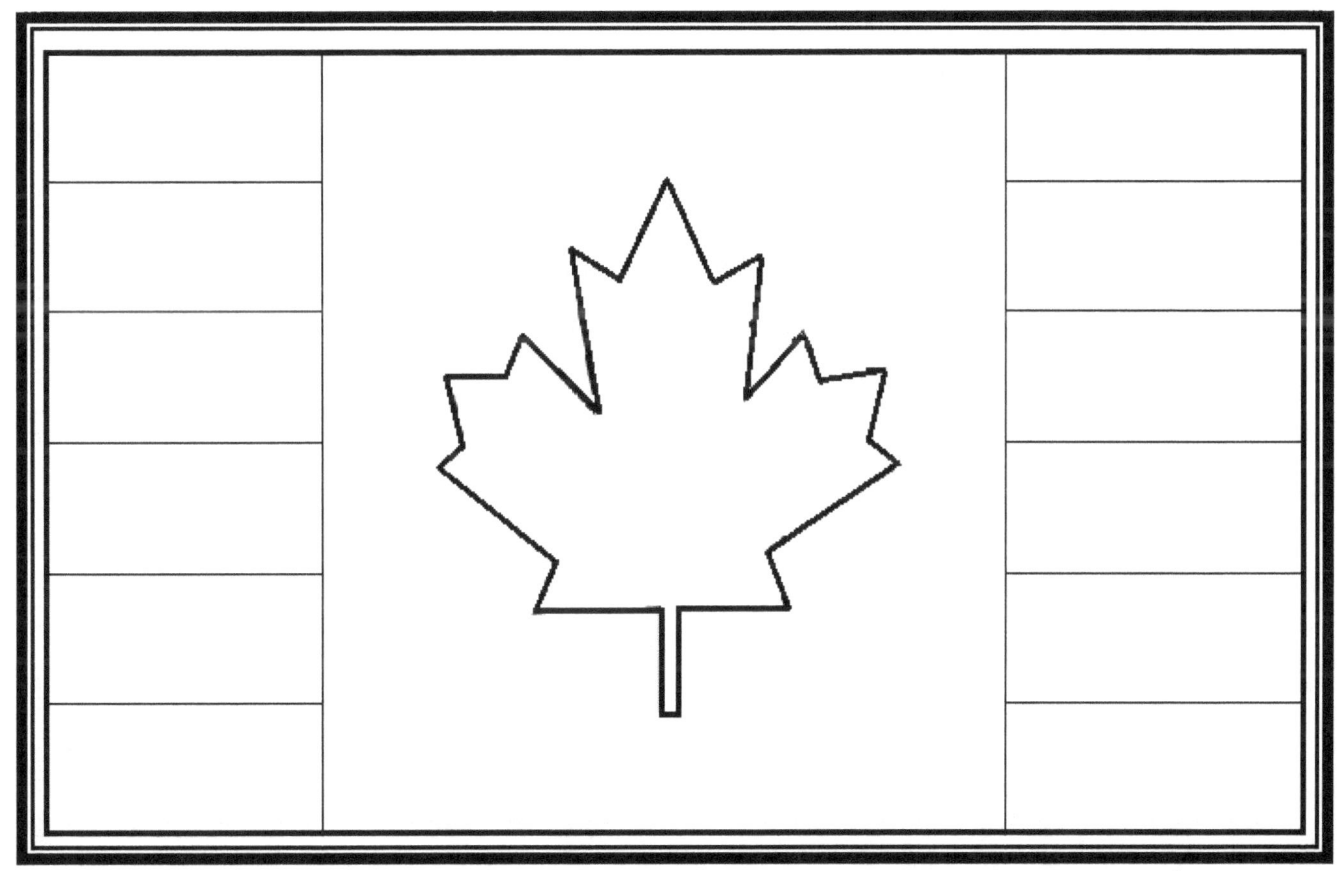

# CANADA PRIDE

The Pride flag of Canada is a blending of the center (Maple Leaf) of the Canadian Flag and the sides of the classic rainbow pride flag.

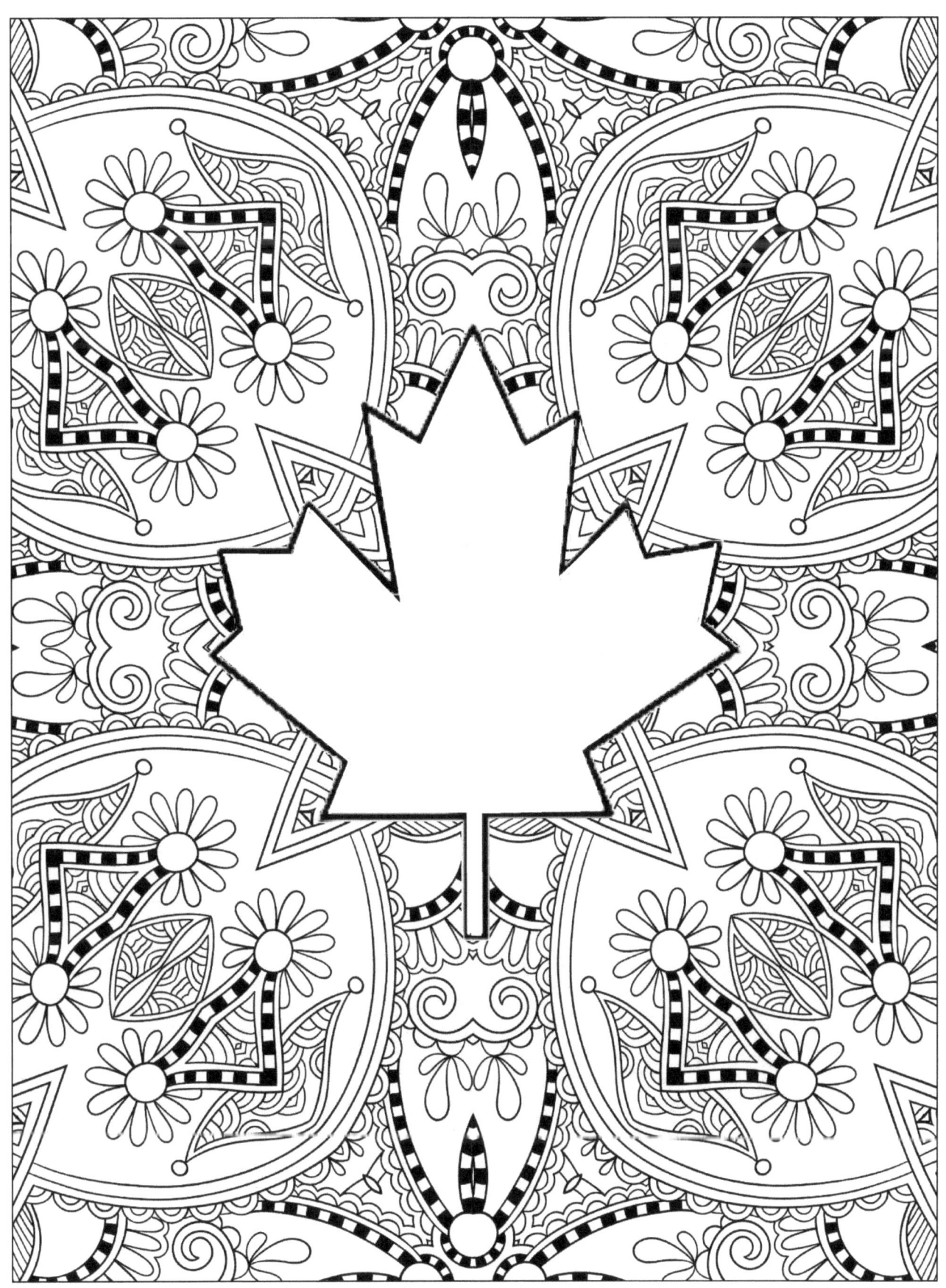

## Did you know?

Since 2013, sex reassignment surgeries and hormone therapy are covered by the public health system in Chile.

# CHILE PRIDE

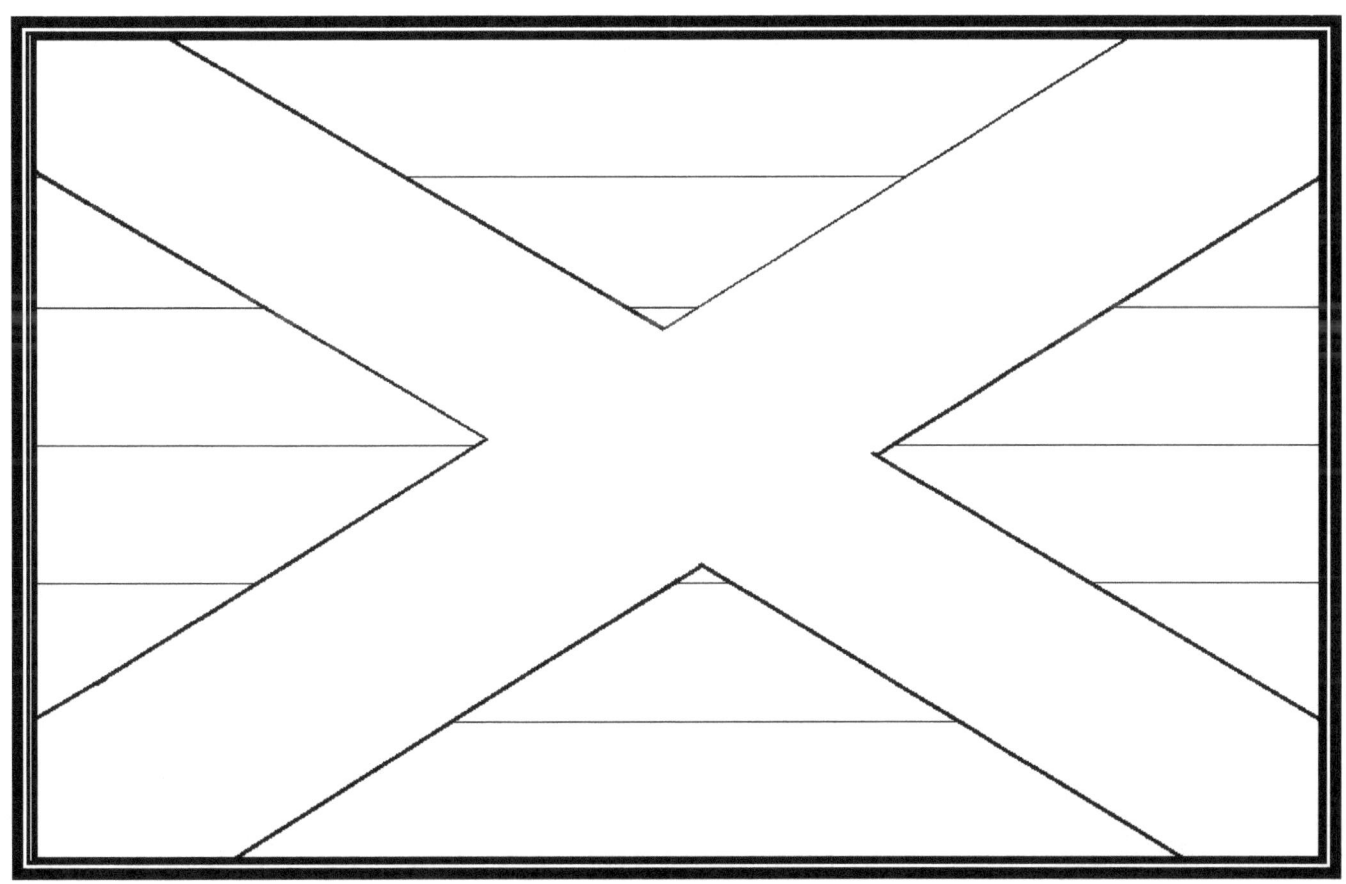

# SCOTTISH PRIDE

### Did you know?

In 2016, the majority of Scotland's major political parties (The Conservative Party, Labour Party, Green Party, and The UK Independence Party) were all led by openly LGBT people.

XOXOXOXO

XOXOXOXO

XOXOXOXO

XOXOXOXO

XOXOXOXO

XOXOXOXO

# TIT-TAC-TOE

XOXOXOXO

XOXOXOXO

XOXOXOXO

XOXOXOXO

TIT-TAC-TOE

FUCKING AWESOME FUCKING AWESOME FUCKING AWESOME

FUCKING AWESOME FUCKING AWESOME FUCKING AWESOME

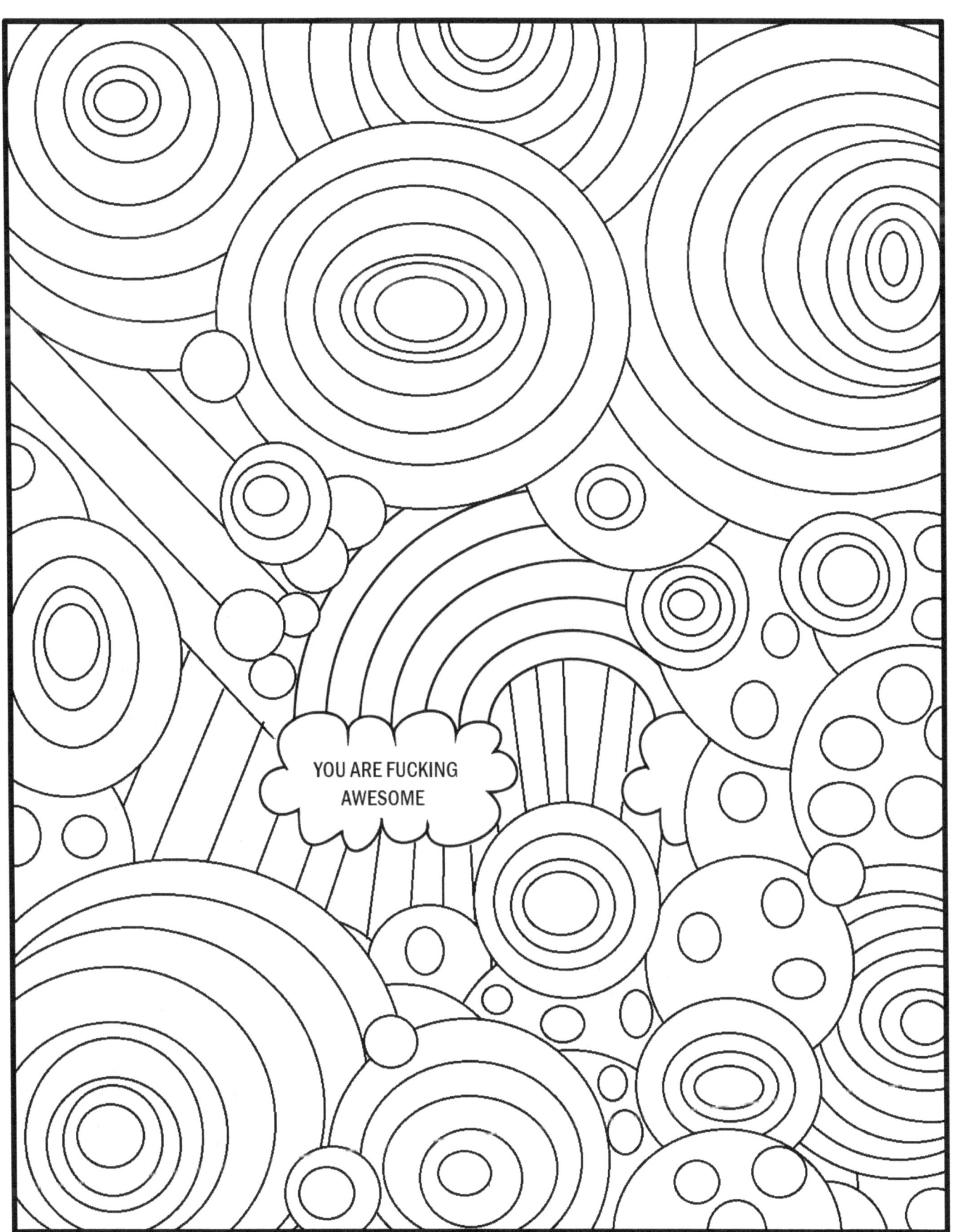

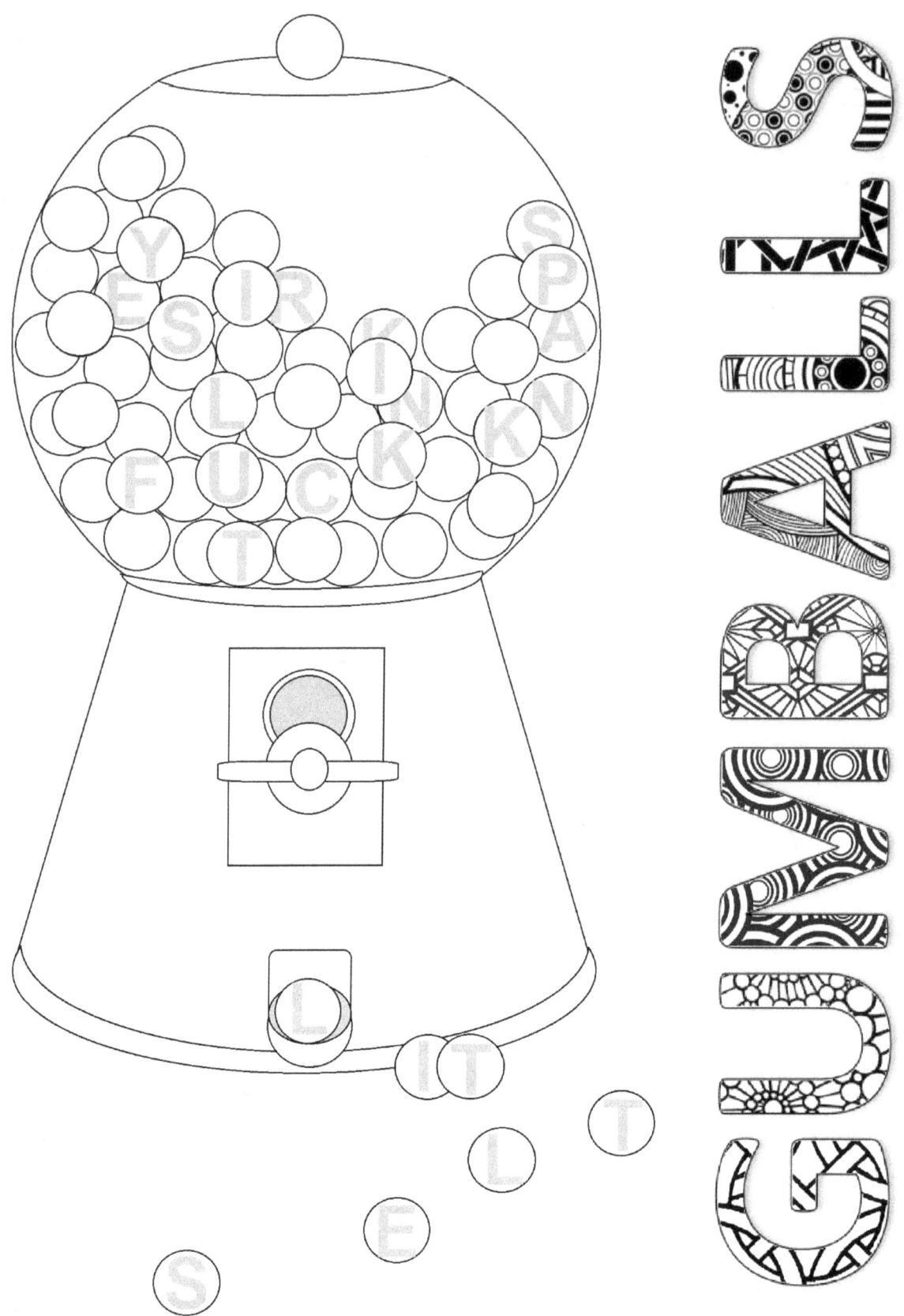

# Naughty List

**Confession is good for the soul (but bad for the bum)**

# Naughty List
Confession is good for the soul (but bad for the bum)

# Naughty List

Confession is good for the soul (but bad for the bum)

_____

_____

_____

_____

_____

_____

_____

_____

_____

_____

_____

# Naughty List

**Confession is good for the soul (but bad for the bum)**

# Naughty List
Confession is good for the soul (but bad for the bum)

# Naughty List

**Confession is good for the soul (but bad for the bum)**

# Naughty List

Confession is good for the soul (but bad for the bum)

# St. Andrew's Sudoku

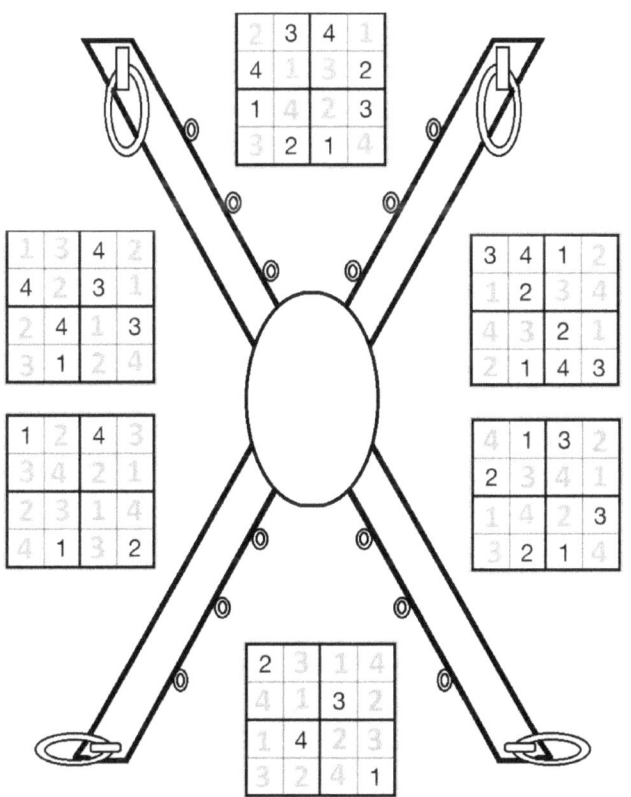

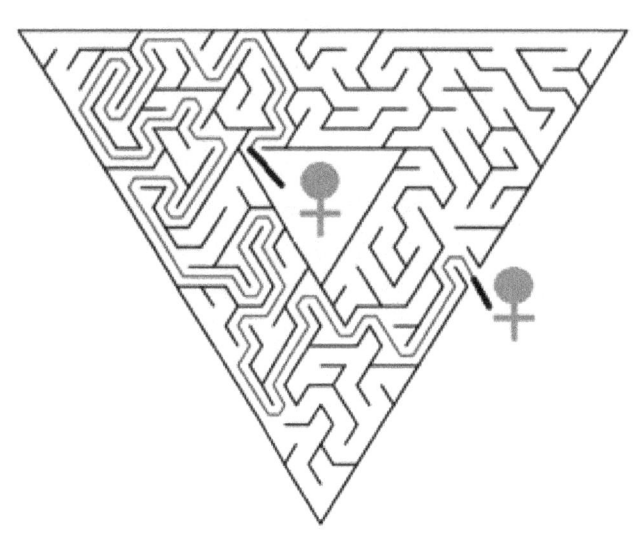

## M/s

1. RLTAEHE — LEATHER
2. EATSMR — MASTER
3. CLLROA — COLLAR
4. BLCOKOATB — BOOTBLACK
5. ISR — SIR
6. LSAVE — SLAVE
7. NKLEE — KNEEL
8. STSEMIRS — MISTRESS
9. CTATRONC — CONTRACT
10. COOLORTP — PROTOCOL
11. CNAMOMD — COMMAND
12. ESY — YES
13. TPORRYEP — PROPERTY
14. OWNRE — OWNER

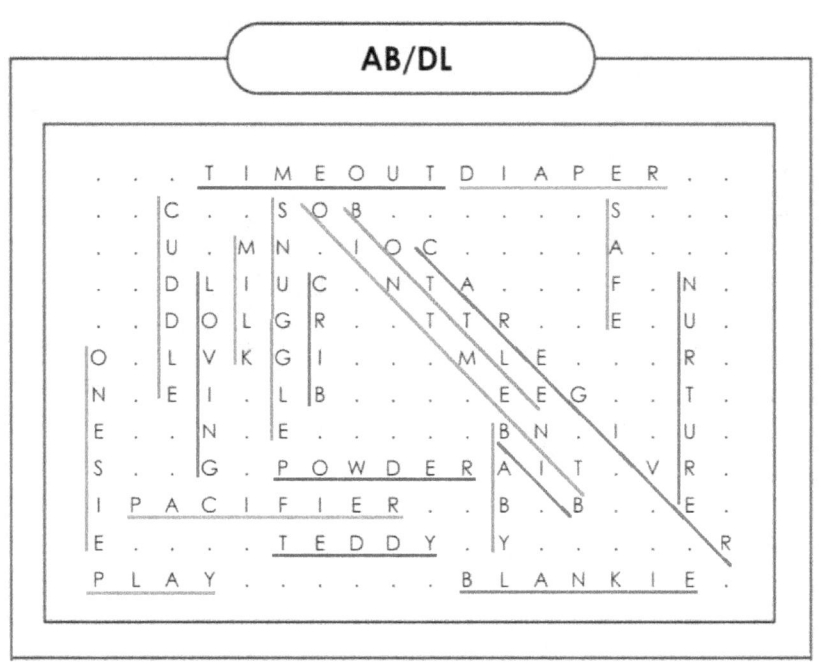

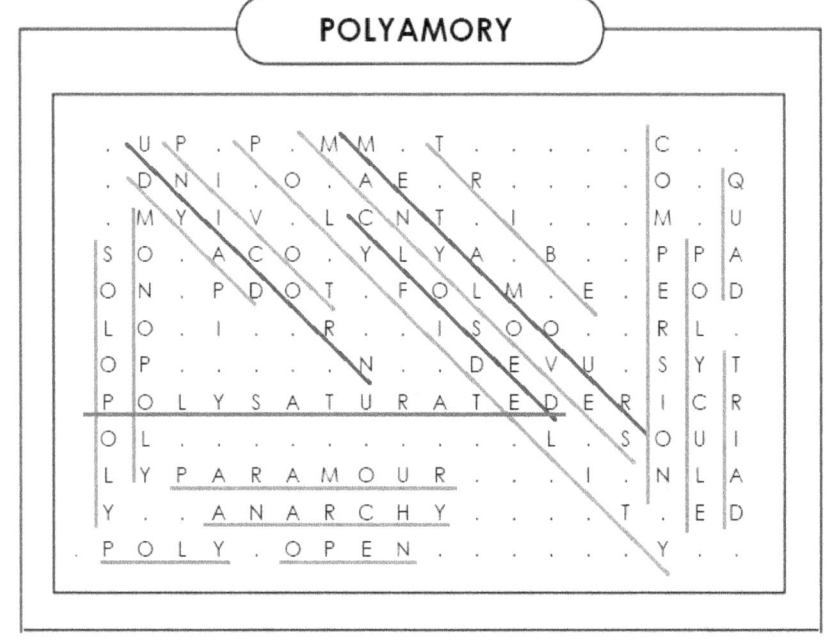

# ABOUT THE AUTHOR

The author has been freaky for a long time, so she was happy to find a community of kinky folks back in 2012. They made her feel safe. *Safe is a very important thing to feel and to be.*

It can be lots of fun to play pretend. The author uses different names when she is playing at work or in the community. Some people call her wawbat and others call her kame bat.

Some grownups are weird and they can be mean when they do not understand things, so when kame bat writes things for work, she uses her regular old boring name.

kame bat loves arts and crafts and often finds herself in the company of littles. She has fun with them and always has arts and crafts around. If you are a very good boy or girl, she's likely to have a treat in her bag.

*You are loved.*

# OTHER BOOKS
## by kame bat

**The Collar** is a planner and journal for those living in purposeful and consensual Power Exchange Relationships. Regardless of the style of your Power Exchange Relationship, your service is a critical component of your daily life. Whether you are new to Power Exchange or a seasoned veteran in the life, this book provides an opportunity to reflect on who you are and why you serve. Those wishing to create their own journal (paper or electronic) should check out the e-book, which includes more information on how you can do just that!

Monthly Rounds and Square Rounds are tracking journals with 36 monthly pages and 27 journaling pages (each)

Available on Amazon.com and at local kink conferences

www.ingramcontent.com/pod-product-compliance
Lightning Source LLC
Chambersburg PA
CBHW080941170526
45158CB00008B/2336